NEW YORK

a tribute
to the city and its people

GERALD & MARC HOBERMAN

TEXT BY RAY FURSE

THE GERALD & MARC HOBERMAN COLLECTION
CAPE TOWN • LONDON • NEW YORK

Photography, concept, design, and production control
Gerald & Marc Hoberman

ISBN 1-919734-49-X

Copyright subsists in this material
Duplication by any means is prohibited without written permission from the copyright holder
Copyright © Gerald & Marc Hoberman

First edition 2001

Published for Eurovast Publications BV by The Gerald & Marc Hoberman Collection (Pty) Ltd
Reg. No. 99/00167/07. PO Box 60044, Victoria Junction, 8005, Cape Town, South Africa
Telephone: 27-21-419 6657/419 2210 Fax: 27-21-418 5987 e-mail: hobercol@mweb.co.za
www.hobermancollection.com

International marketing and picture library
Hoberman Collection (USA), Inc. Representing The Gerald & Marc Hoberman Collection
PO Box 810902, Boca Raton, FL 33481-0902, USA
Telephone: 91-561-542 1141 Fax: 91-864-885 1090 e-mail: hobcolusa@yahoo.com

Agents and distributors

International inquiries	*United States of America, Canada, and Asia:*	*United Kingdom and Republic of Ireland:*
Eurovast Publications BV	BHB International, Inc.	John Wilson Booksales
Paradijslaan 70, 4822 PG	108 E. North 1st Street	1 High Street, Princes Risborough
Breda, The Netherlands	Suite G, Seneca, SC 29678	Buckinghamshire, HP27 0AG
Tel: 31-76-541 8815	Tel: (877) 242 3266	Tel: 44-1844-275927
Fax: 31-76-542 5932	Fax: (864) 885 1090	Fax: 44-1844-274402
e-mail: eurovast@yahoo.com	e-mail: bhbbooks@aol.com	e-mail: sales@jwbs.co.uk

Printed in South Africa

THE WORLD TRADE CENTER

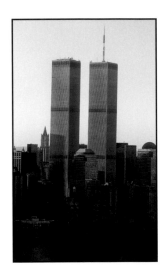

IN MEMORIAM
1970—2001

THIS PUBLICATION IS DEDICATED TO THE MEMORY OF ALL THOSE WHO PERISHED IN NEW YORK, WASHINGTON D.C., AND PENNSYLVANIA FOLLOWING THE SEPTEMBER 11, 2001 ATTACK ON THE UNITED STATES OF AMERICA. SO MANY INNOCENT PEOPLE, BOTH AMERICANS AND CITIZENS OF OTHER COUNTRIES AROUND THE WORLD, DIED. THEIR LOVED ONES AND THE WORLD ARE LEFT GRIEVING AS A RESULT OF THIS CRIME AGAINST HUMANITY.

"The World Trade Center is a living symbol of man's dedication to world peace..."

—MINORU YAMASAKI, CHIEF ARCHITECT, WORLD TRADE CENTER

"My grandfather was not alive to see those towers crumble. It would have devastated him as it has devastated all of us."

—KATIE YAMASAKI

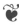

"Let every nation know, whether it wishes us well or ill, that we shall pay any price, bear any burden, meet any hardship, support any friend, oppose any foe to assure the survival and the success of liberty."

—PRESIDENT JOHN F. KENNEDY, INAUGURAL SPEECH, 1961

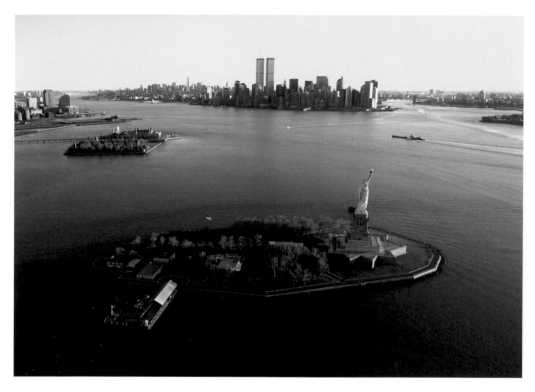

BEACON OF FREEDOM

The interpretation of America's revolutionary monument, the Statue of Liberty, as a beacon of freedom for the world's oppressed was strengthened by the experience of refugees. Most would spend several days in immigration processing on Ellis Island (middle left). Across the water, Lady Liberty beckoned all who entered New York Harbor to the golden promise of America. These thoughts were eloquently expressed by Emma Lazarus in an 1883 sonnet, "The New Colossus," in which the statue speaks: "Give me your tired, your poor / Your huddled masses yearning to breathe free / The wretched refuse of your teeming shore / Send these, the homeless, tempest-tossed to me / I lift my lamp beside the golden door!"

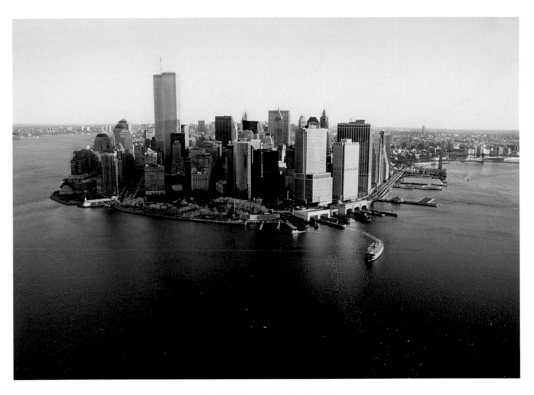

A DAY OF INFAMY

At 8:45 a.m. on September 11, 2001, terrorists crashed a fully fueled Boeing 767 commercial jetliner into the north tower of the World Trade Center; at 9:03 a.m. a second 767 jetliner hit the south tower. The 1360-foot towers shuddered as they absorbed the impact of the crashes, and stood firm. But inside, blazing infernos fed by 60,000 gallons of jet fuel reached more than 2000 degrees, heating and weakening the steel structures until they were unable to support the stories above. The south tower collapsed 56 minutes after impact. The north tower lasted an hour and 40 minutes. Over 6000 people died, the worst one-day casualty toll on American soil since the Civil War.

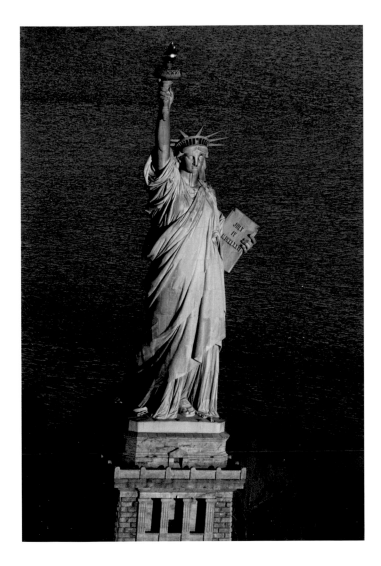

STATUE OF LIBERTY

Two of the most popular beliefs about the Statue of Liberty—that it was given to the United States by the French government and that it was intended as a beacon of hope for refugees around the globe—are incorrect. Construction of the monument was a joint effort between the ordinary citizens of France, who paid for designing and building the statue, and the American people, who raised funds for the base. Its purpose was to reaffirm the friendship between the two countries—France had helped the colonies win their independence from England—and to commemorate the 100th anniversary of the American Revolution. On the tablet held by "Lady Liberty" is July 4, 1776, the date of the American Declaration of Independence.

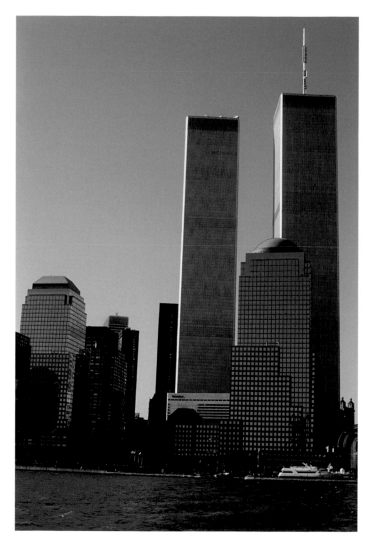

THE MOUNTING TOLL

Two weeks after the destruction of the World Trade Center on September 11, the list of missing stood at more than 6000, while due to the enormity of the damage the official number of bodies recovered stood at less than 300 and the city medical examiner had identified less than 200 of those. Although these horrific numbers were described by New York's Mayor Rudolph W. Giuliani as perhaps "more than we can bear," the disaster could have been far worse. The entire World Trade Center complex, which includes four more smaller buildings, is used by 50,000 workers and visited by up to 100,000 people each day.

BATTERY PARK CITY

This vast commercial and residential complex adjacent to Battery Park on the lower west side of Manhattan occupies 92 acres, over a quarter of which is landfill resulting from excavation for the World Trade Center. In spite of a slow start, the complex today is hugely successful, with a lovely esplanade along the Hudson River linking restaurants, public spaces, and artworks, making it a popular destination for a summer weekend. Sadly, this specific view can no longer be enjoyed; the building at the upper left is the façade of one of the two towers of the World Trade Center that were destroyed during a terrorist attack on the United States on September 11, 2001.

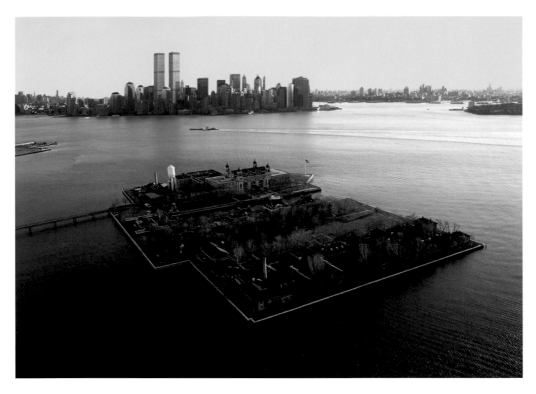

ELLIS ISLAND—ISLE OF HOPE

John F. Kennedy wrote: "There were probably as many reasons for coming to America as there were people who came." And come they did. Named after a merchant who purchased it in the eighteenth century and later sold it to the government, Ellis Island was from 1892 to 1954 the headquarters of the local office of the Immigration and Naturalization Service. During that time about twelve million immigrants entered the country through it. Closed in 1954, the immigration station was dedicated as a museum in 1990. Ellis Island stands as a reminder that the United States is a nation of immigrants, and more importantly, that the surest path to greatness is through offering opportunity to all.

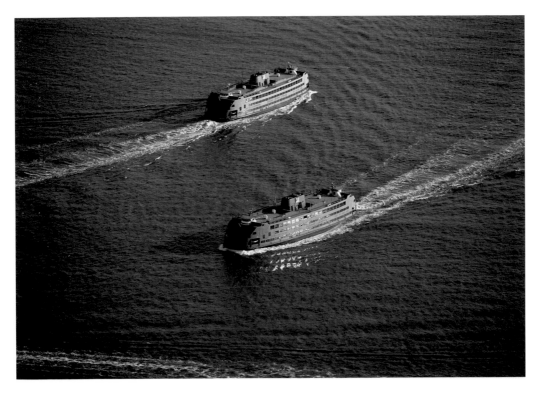

STATEN ISLAND FERRIES

In 1609 Henry Hudson, who sailed for the Dutch, gave the large island south of Manhattan its name, Staaten Eyelandt (after the "States General," the governing body of the Netherlands). In 1661 French and Dutch farmers and fishermen established the first permanent colony there. Cornelius Vanderbilt, America's great nineteenth-century railroad baron, was born on Staten Island, and as a teenager in 1810 started his transportation empire with a regular ferry service to Manhattan. This view of inbound and outbound ferries was taken from the observation deck of the World Trade Center, which was destroyed less than six months later.

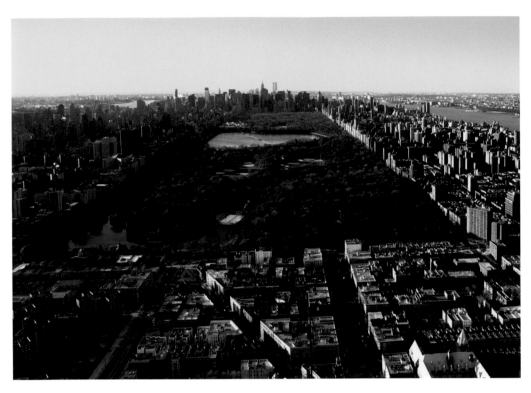

CENTRAL PARK—AN URBAN OASIS

Looking south from northern Manhattan, it is easy to see why Central Park is called "the lungs of the city." By the mid-nineteenth century it was clear that development would ultimately engulf Manhattan and that a city park was desperately needed. In 1856 the city purchased for $5 million what was then a desolate stretch of property (now central Manhattan between 59th and 110th Streets), occupied by a garbage dump and the pigs and goats of squatters. Today this great park is one of the urban wonders of the world, a green oasis in the great concrete, high-rise landscape of the city.

CITY HALL PARK

This lovely park to the south of City Hall is a small triangle formed by the intersection of Park Row, which in pre-Revolutionary War days was the Boston Post Road, and Broadway. It was an important crossroads and, planted with apple trees, it served as a common for New York residents. In July of 1776 the newly drafted Declaration of Independence was read here to George Washington and his troops. The park contains a statue of Nathan Hale, the Revolutionary War hero who was captured and hung at age 21 after boldly declaring: "I only regret that I have but one life to lose for my country."

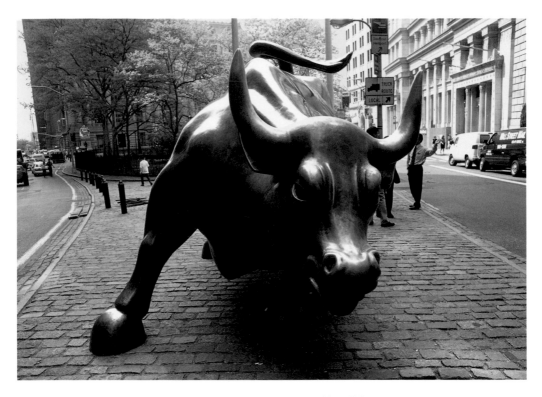

THE FINANCIAL DISTRICT

Guarding the northern entrance to Bowling Green is a 3.3-ton bronze bull, installed in 1988. Pawing the ground with its head lowered, the bull appears ready to charge through the Financial District to the north. However, in the aftermath of the attacks on the World Trade Center in September 2001, it was hard to be bullish. The financial markets, closed for four days, reopened to be hammered by $1.38 trillion in paper losses the first week, down 14.3 percent, the biggest weekly slide since the Great Depression. Still, analysts insisted, the national economy was fundamentally sound and reconstruction would eventually mean big capital spending.

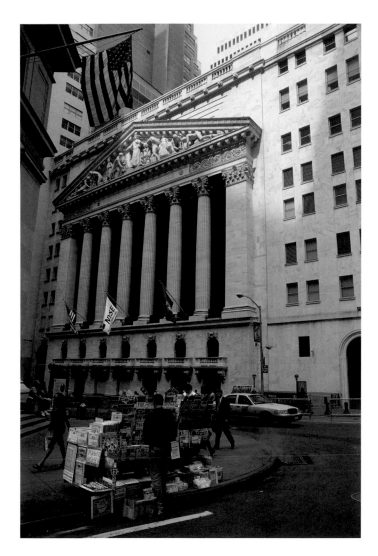

NEW YORK STOCK EXCHANGE

Visitors should not be fooled by the classical revival façade of the New York Stock Exchange's 1903 building. In fact, its main trading floor has been renovated and updated to facilitate the swift flow and display of massive amounts of information and an ever-increasing trading capacity. After two centuries of growth and innovation, the NYSE remains the world's foremost securities marketplace, raising more capital than any other market in the world. More than 2900 companies are listed on the exchange, whose combined 315 billion shares available for trading are worth more than $12 trillion in total global market capitalization, more than three times that of any other market.

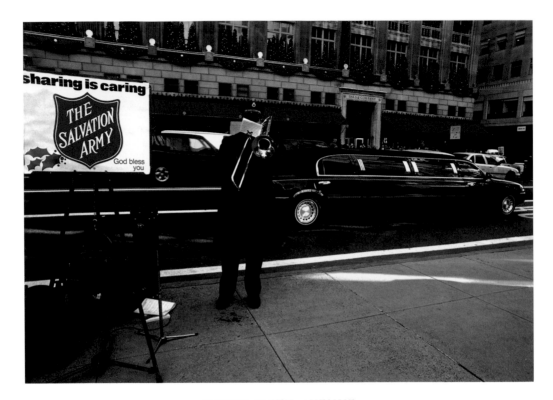

UPPER FIFTH AVENUE

The denseness of the urban environment often seems to magnify differences between people—
their dress, their jobs, their lives and livelihoods. As one of the world's largest and most diverse
cities, New York provides endless studies in contrast, often between the rich and poor.
Unfortunately, America's prosperity of the last decade has not benefited all members of society
equally. Here, on upper Fifth Avenue, a "stretch limo" whizzing by holiday shoppers while a
Salvation Army soldier collects for the poor, makes this disparity abundantly clear.

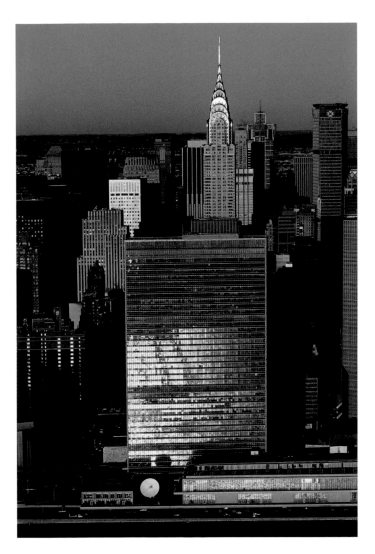

UNITED NATIONS
HEADQUARTERS

In 1941 President Franklin D. Roosevelt coined the term "United Nations" to describe the allied countries opposing Germany. The UN charter was ratified in San Francisco on October 24, 1945, now celebrated as United Nations Day, and headquarters for the new organization were built in New York City on an $8.5-million tract of land donated by John D. Rockefeller. The main buildings of the complex, completed in 1952, are the General Assembly, the Conference Building, and the Secretariat, a 39-story office tower (seen here), accommodating 3400 employees. Although the United Nations has not achieved the world peace that many had hoped it would, it has successfully intervened in a number of conflicts and crises to end or avert escalating conflict.

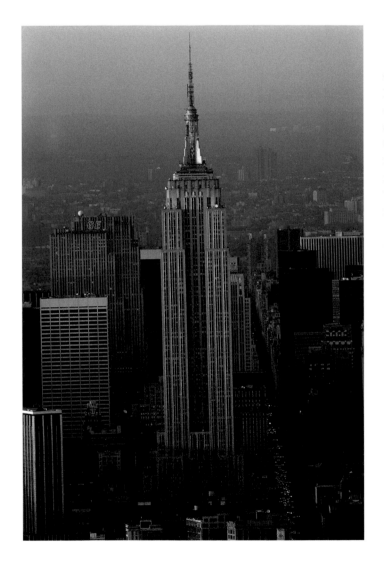

EMPIRE STATE BUILDING

Completed in 1931, the Empire State Building is one of the world's most famous skyscrapers. Visitors continue to throng to observation platforms on the 86th and 102nd floors, where from the latter they can gaze over the city from 1250 feet; it is another 222 feet from here to the top of the tower. Although it has long since relinquished its claim as the world's tallest, the Empire State Building remains one of New York's most enduring symbols. Its graceful outline comes to mind whenever one recalls the city's romantic skyline. This is where Deborah Kerr broke Cary Grant's heart in *An Affair to Remember*, where Tom Hanks finally met Meg Ryan in *Sleepless in Seattle*, and where the beauty of Fay Wray killed the beast in *King Kong*.

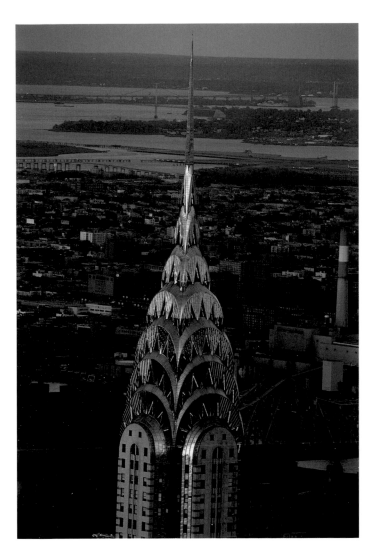

CHRYSLER BUILDING

Although the world's tallest building for only a single year after it was built in 1930 (the Empire State Building was completed the following year), the slender, soaring Chrysler Building is considered one of the city's most impressive and recognizable skyscrapers. Finished in fine African woods and marbles, its elegant lobby is an Art Deco treasure, while the use of massive quantities of stainless steel betray, indeed trumpet, the building's automotive heritage. Architecture critic Paul Goldberger wrote: "The quality of the Chrysler comes from its ability to be romantic and irrational, and yet not quite so foolish as to be laughable; it stops just short, and therefore retains a shred of credibility amid the fantasy—rather like New York itself."

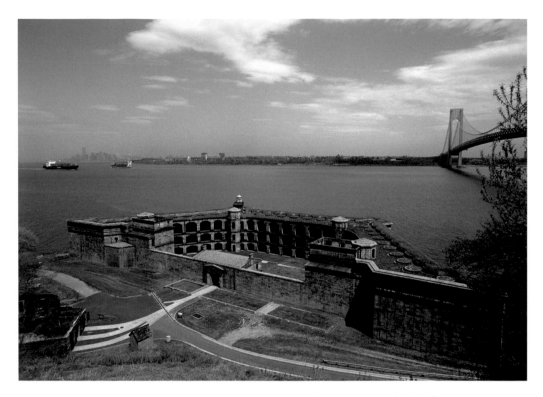

BATTERY WEED AND VERRAZANO NARROWS BRIDGE

Nestled beneath the soaring Verrazano Narrows Bridge in a quiet pocket of Staten Island, Fort Wadsworth is the oldest continually staffed military reservation in the United States; a fort occupied the site as early as 1663. The reason for the location of both bridge and fort, with its long-unused gun emplacements of Battery Weed shown here, is one and the same: this is the "Narrows," where the boroughs of Staten Island and Brooklyn are closest, and through which enemy ships had to pass to attack New York Harbor (lower Manhattan and the towers of the World Trade Center can be seen in the distance). Though silent, the fortress stands as an eloquent reminder that the United States is long used to defending itself, and is prepared to do so again.

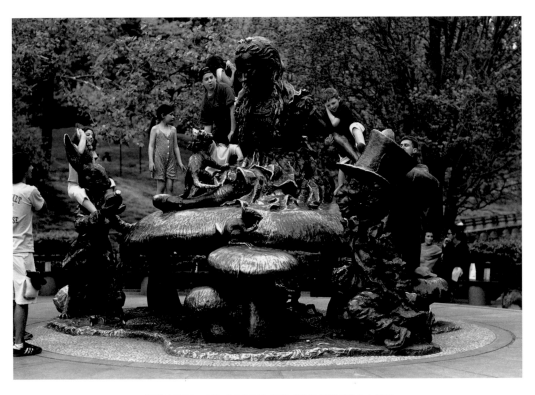

STATUE OF ALICE IN WONDERLAND

A favorite destination for children visiting Central Park is José de Creeft's tableau of the beloved characters from Lewis Carroll's *Alice in Wonderland*. Alice perches on the largest of a group of mushrooms, while the March Hare examines his pocket watch and frets about the time, the Dormouse nibbles on a snack, the Cheshire Cat catches Alice's eye, and the Mad Hatter ponders his own vision of reality. Nearby, a statue of Hans Christian Andersen by Georg John Lober shows the master of fairy tales sitting on a bench with a book spread open on his legs. The smooth surfaces of both works attest to the many small arms and legs that have lovingly clambered over them.

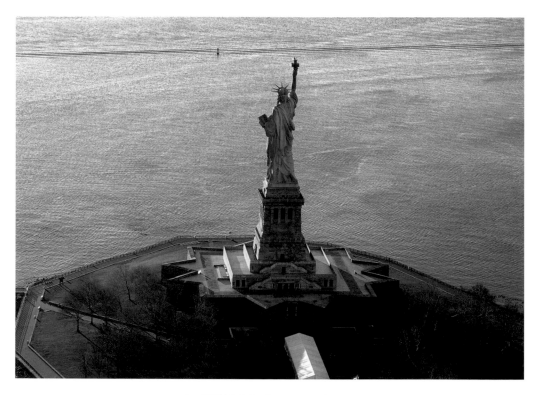

A SYMBOL OF FREEDOM

Designed by sculptor Frédéric Auguste Bartholdi, "Lady Liberty" is one of the most widely recognized structures in the world. Interestingly, when the sculptor needed an engineer to assist him with this massive project, he turned for help to the designer of another well-known monument—Alexandre Gustave Eiffel. Together, they devised a system to attach 31 tons of copper sheathing for the statue's "skin" over 125 tons of steel structural members. "We will not forget that Liberty has here made her home; nor shall her chosen altar be neglected," said President Grover Cleveland as he accepted the Statue of Liberty on behalf of the United States in 1886.